action-packed superheroes

your guide to revealing and utilizing your superpowers
written and illustrated by Renne Emiko Brock aka Bow Girl

Many thanks to all the Action-Packed Supeheroes in my life.

This book is dedicated in the memory of my brother,
Alan James Brock.

Text and illustrations copyright © 2001 - 2019 by Renne Emiko Brock. All rights reserved.

action-packed superheroes - your guide to revealing and utilizing your super-powers. 1 v.
2019-08-22

Action-packed Super-Hero : your guide to revealing & utilizing your super-powers. 1 v.
TXu001081731 / 2002-12-03

No part of this book may be reproduced in any form without written permission from the publisher.

ISBN-13: 978-0-578-56792-1

Copy editing by Teri Forsythe, Dona Brock, and Tina Cook.

Renne Emiko Brock
P O Box 2633, Sequim, WA USA
renneemikobrock.com
uniqueasyou.com
hueareyou.com

purple wagon

Neighborhood kids pulled
Their red rectangle wagons
Up and down the block
My brother and I proudly
Drew our prized wagon out
Shining in the sunlight
The purple round wagon shone
Its brilliance dulled under
Teasing children's drone
We demanded understanding
What was wrong with
The unique and the unusual
They enforced the rule
Stick with the pack of boredom
Four wheels instead of five
Our difference becomes fuel
Unconventional we did strive
Launching our imagination
Farther than they could ride

by Renne Emiko Brock
copyright 1993

be super!

Do you have an energetic zeal with a hint of virtue? Do you feel like you have amazing, yet misunderstood talents? Do you have a sense super villains are scheming against you? Discover in this guide what you do to be super everyday in everyway as one of the Action-Packed Superheroes!

contents

7	Welcome
8	Superhero Origin Story
9	Pre-Heroes
11	Transformation into a Superhero
12	Tragedy — Mutation
13	Catalyst
18	Balance and Motivation
23	Super Colors and Branding
24	Super Expression and Costume
69	Superpowers
79	Super Name
81	Improvement and Acceptance
83	Case Studies
84	Sphere of Influence
85	Ready for Action
86	Identity Assets
90	Etiquette
91	Reputation and Responsibility
92	Your Action-Packed Superhero

Welcome

This guide is about intentional evolution and growth with all its challenges and rewards. This isn't role-playing, this is your real life. Looking foward to the future, scientists have made predictions as to how the human species will continue to evolve.

How will you evolve?

This is an interactive guide and your personal evolution story. How do you use it? In this guide, you'll learn about the challenges of Pre-Heroes and Superheroes, consider the catalysts that transform one into the other while revealing motives and assets. While delving into the evolutional accounts of Superheroes, you'll use the interactive questions, color meaning pages, superpower pages, and profile pages at the end in this guide to define your own superhero persona.

Because you are going to have new experiences, aspirations, and just change your mind as will your unique Action-Packed Superhero persona selections. You are always advancing and evolving.

Examine the real-life Superhero Case Studies as a reference and alter your extensive profile pages at the end of the guide to update your transformation. For "super" insight, you might want to share your ideas and dreams freely with friends and family. Keep a dictionary or thesaurus handy!

Imagination is more powerful than might. Enjoy being creative in this process.

This guide is all about you. Have fun! Be super!

Origin Story is a tale about how a superhero came into being defining their catalyst, transformation, and mission. Your superhero origin story is unique and communicates who you are.

Why do origin stories inspire us? They are about overcoming adversity and reveal the pure motivation that keeps our hero reaching farther and higher. Discovering a common cause binds a super team together and helps find new friends along the way. The hero's best self is revealed through action.

It might seem odd and difficult to look at yourself in superhero terms. Think of superpowers as strengths that you want to share. Consider what makes you unique, and celebrate your abilities whether as an individual or as part of a team.

Think about yourself: what actions, colors, stories, snacks, dreams, smells, and catchphrases come to mind?

Elements of an Origin Story

What is your story? This is the superhero's story that changes their lives and uncovers the incentive to improve themselves and the world around them.

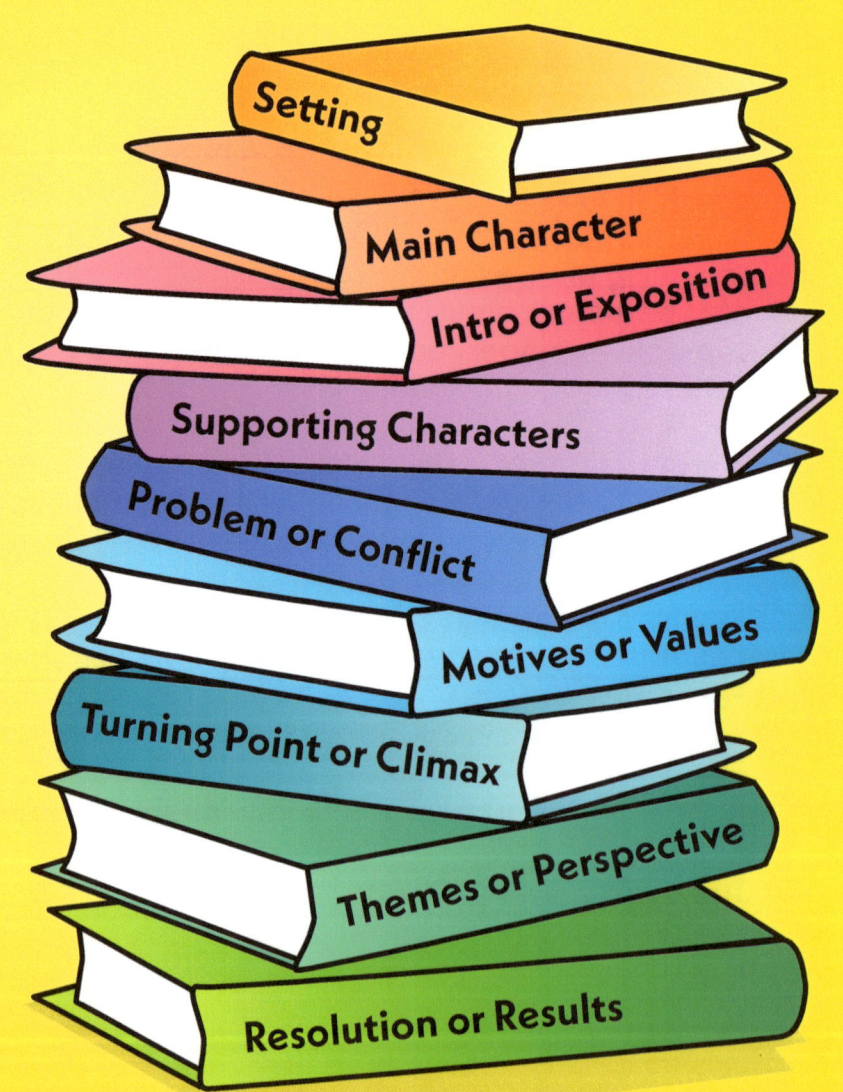

- Setting
- Main Character
- Intro or Exposition
- Supporting Characters
- Problem or Conflict
- Motives or Values
- Turning Point or Climax
- Themes or Perspective
- Resolution or Results

Pre-Heroes and Isolation

Have you evolved from a Modern Human into a Pre-Hero?

Those attempting to distinguish themselves from the pack are Pre-Heroes. Improving themselves and gaining notice by performing impressive acts motivates Pre-Heroes.

Pre-Heroes champion what is admirable and extraordinary, or "cool." Being famous in their own minds is enough. This delusional state boosts the ego tempers the desire for fame later in life. Although Pre-Heroes appear to have chips on their shoulders, they are very concerned about their fellow humans. That chip could evolve into steadfast compassion or a fashionable short fuse.

They also enjoy sharing war stories with other Pre-Heroes in an appetizer-rich environment. If the Pre-Hero feels apart from or is mocked by status quo, natural selection, and hence, (r)evolution, has begun. Pre-Heroes often feel like it is them against the world, even when they are the ones trying to save it.

Does this sound familiar? Or, is this your future?

Little things that annoy Superheroes (or mounting evidence you've encountered Supervillains):

· Impediments to kind freedom.

· Letting a car in and no "thank you" wave from the driver.

· Litter, anytime - anywhere.

· Consumer height discrimination.

· Someone cutting in line.*

· Not getting your salad dressing on the side.

· Someone is stepping on your cape, again.

*Tricky, didn't you do it to see Star Wars opening day?

Transformation into a Superhero

In many ways, experiencing life as a Pre-Hero is preparation for a Superhero existence. Bolstering their egos strengthens Pre-Heroes so that they can endure the adversity of the transformation into Superheroes.

The catalyst metamorphosis forces Pre-Heroes inside out, submerging their toughened hides and exposing their raw and delicate natures.

The fine line between Superhero and evil Supervillain is defined at this tender moment of exposure. The simple divide can be selfishness and selflessness. Depending on the circumstances, the perceived differences between the two depend solely on eyewitness testimony.

Supervillains deny any responsibility for or repercussions from their actions. Superheroes' strong suit is accountability. Superheroes may suffer from lack of recognition and validation. People assume heroes will do good deeds anyway, so why encourage natural behavior?

Tragedy or Mutation

Most Superheroes come into existence by way of significant catalyst or personal tragedy, trauma, accident, great loss, or physical or intellectual mutation. A mutation through education or altered perspective isn't a visible transformation. This tragedy or mutation is the catalyst that launches an ordinary citizen into Super-Herodom.

Has this happened to you? How you react defines you.

Catalyst

Catalysts expose weaknesses (your challenges, or what makes you mad or sad) and reveal motivations and strengths (your superpowers, or what makes you glad or rad). Exploring your weaknesses and strengths will allow you to identify your motivations and mission.

Some superheroes may devise two different personas: mild-mannered citizen and bigger-than-life savior to protect themselves and those they love.

The difference between these two identities can lead to confusion, a larger wardrobe, and credit card bills attributed to eyewear expenses.

How did this powerful event influence you?

Take your time and reflect on your past, present, and possible future. To uncover the impact of your tragedy, mutation, and / or catalyst by answering all the catalyst inquiry questions:

mad!

What especially angers you?

What creates animosity and fury?

How do you combat this anger or frustration in your daily life?

What makes you sad, agitated, or agonized?

What overwhelms you to the point of frozen obstruction?

When a problem occurs how do you react?

glad!

When do you feel the most like your true self?

What accomplishments delight you?

What are you really good at? Brag!

rad!

Which of your abilities are you proudest of?

When did you feel like you made a difference?

Hands on hips! What do you stand for?

Finding Balance

The catalyst inquiry questions uncover your transformation, aspiration, and courage. Later you will consider how they connect with your superpowers and limitations.

If you compare your strengths and weaknesses, are they complementary?

Do they balance one another?

How are they connected to each other?

Often what gives us great strength also can expose our vulnerability. Your disadvantages build gifts and forte full of determination and energy to over come any and all obstacles.

Catalysts define much that drives a superhero. Always reveal who you are, who you are meant to be. Regardless of fate, you still pursue your mission.

Motivation

Action-Packed Superheroes try to make sense of the world and their place in it with conviction, courtesy, and courage. Take a deep breath.

What is your mission?

How do you want to react to the world?

| physical & optimistic | expressive & enthusiastic | emotional & practical | intellectual & spiritual |

How do you want to engage with the world?

| affect | exchange | observe | analyze |

How do you want to act upon the world?

| do | express | feel | think |

What you accomplish through your actions defines what kind of superhero you are.

affect

exchange

demonstrate
self
education

do

express

invent modify
lead report
participate perform

build
production
business

teach
make share
listen

network
communication
media

program perceive
investigate support
imagine coordinate

think

feel

collaborate
society
nonprofit

analyze

observe

How you positively participate in the world and foster others defines your mission.

20

Case Study: Bow Girl

Subject: Tragedy and Catalyst

Bow Girl was born out of feelings of exclusion and great loss, particularly over the death of her brother. Over the years, she and her brother had experienced exclusion and mockery because they had the courage to be their expressive selves. Bow Girl retaliated against it with art and her brother couldn't endure the pain.

Her catalysts launched a stronger persona that expresses reverence and respect for individual differences, as well as the ability to draw attention to the consequences of asinine actions and unkind remarks about being different.

Bow Girl's Catalyst Answers:

mad - intentional ignorance and lazy assumptions.

sad – being misunderstood or not given an opportunity.

glad - to create, share, teach, and encourage.

rad - drawn to be a leader, which is isolating experience, but at the same time just longs to belong.

Subject: Mission

Bow Girl wants to inspire acceptance, respect, consideration, and forethought for the feelings of others.

What do Action-Packed Superheroes think about?

- ▇ Improving expression.
- ▇ Why is this song stuck in my head?
- ▇ Creating connections to implement harmony.
- ▇ Pizza/Donuts/Chocolate.
- ▇ Simple ways to inspire.
- ▇ Spell check, truly amazing.
- ▇ Boosting joy.
- ▇ Shoes.

Super Colors and Branding

Hue are you? Efficiently express integrity by embodying your best self through your Super Colors and Branding. Color gives explicit messages. With color, Superheroes can instantly communicate their purpose and articulate their true nature.

What is Branding? A brand is defined as a name, term, sign, symbol or design, or a combination of them intended to identify the goods and services of business and to differentiate them from those of another. A successful brand will achieve these objectives: Articulate your message distinctly. Demonstrate your credibility. Emotionally connect to your target. Inspire the audience. Solidify loyalty.

Articulate what you want people to know about you through your persuasive, persistent presence. Visually embody your mission, brand, and professional reputation through your colors. Being yourself is the main thing.

A superhero has to be genuine to themselves, their high morals, and others. Like H2O, regardless of form the substance remainds the same.

Super Expression Super Costume

Action-Packed Superheroes have to rely on first impressions. Your super costume is an apparel assemblage that expresses your mission through outward appearance. It is not a disguise.

The most important part of a costume is the color and what it represents. Color gives explicit messages. For example, those messages express how gregarious, serious, thoughtful, or shy a superhero is. With color, superheroes can instantly communicate their purpose and articulate their true nature.

Your Action-Packed Superhero super costume will easily announce from a great distance that you are on the way. This gives Supervillains a clear signal to get the hell out of the way. Your costume doesn't have to be like in the comics with a full spandex bodysuit with dramatic cape. It is an outfit you feel super in. Many costume possibilities could be lurking in your own closet, at a favorite clothing store, or freshly made from a sewing machine.

To pick your costume color choices, go to the color choices page. Each color has its own page with a list of definitions. Choose 3 to 4 colors that you are most attracted to or cherish. You might not usually wear these colors, but they inspire distinctive energy in you.

To simplify specific messages, the color choices are pure hues. If you prefer a darker shade or lighter tint of a color, then also choose a black (darker) or a white (lighter). They have meaning as well.

On the color choices page, try to pick your colors based on what you see and sense. Please pick the colors first, then discover what the color communicates on the corresponding page number under the color name to learn what they mean.

A little bit about color...

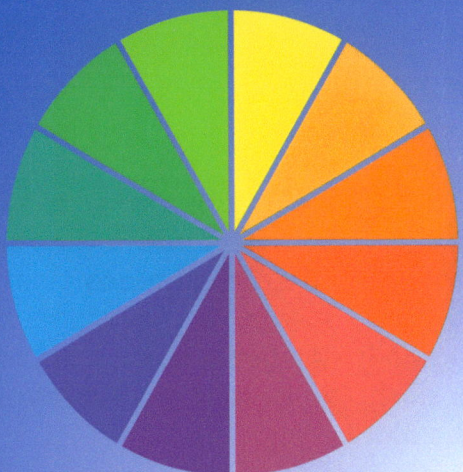

the color wheel

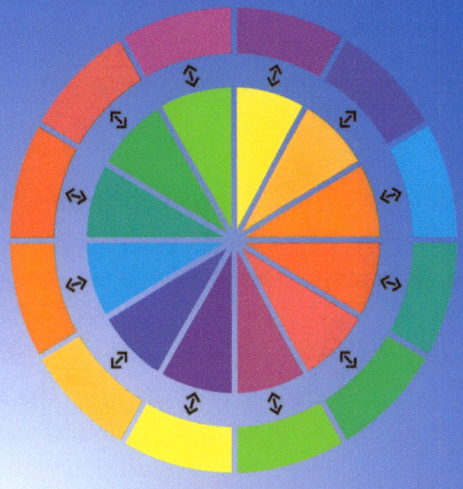

the complementary color is the opposite color on the wheel

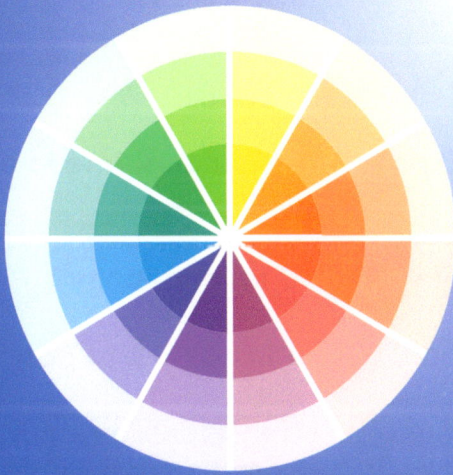

a tint is a color with white added

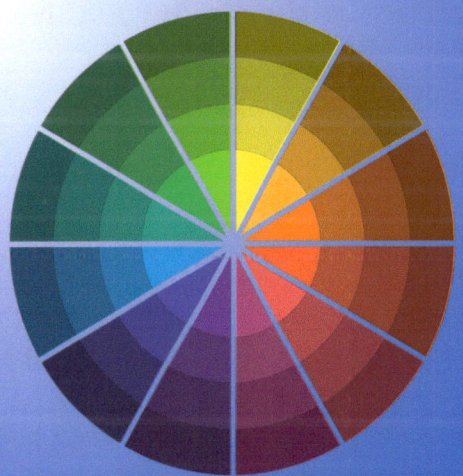

a shade is a color with black added

Picking Your Super Color Choices

Please read these directions first:

Review the 40 colors on the opposite page. Out of the 40 colors, what are your 3 to 4 cherished colors?

They are hues you adore: one that motivates you, one that describes you, and one that inspires you. That fourth extra one means you love color! You are choosing colors that you are most attracted to and inspire you. Write down these color choices.

Next select a favorite color out of the ones you originally choose. Looking at the color wheel, find the color that could be the opposite or complementary of your favorite color. For example, blue - orange. Write down this color.

Each color has a meaning or quality connected to it. Now find your colors in the following pages and read the definition page of your 3 to 4 favorite colors. As you read the definitions ask yourself these questions:

Do they describe the superhero you strive to be?

How do you articulate these super qualities inside of you?

Can you wear these colors as part of your Super Expression Super Costume to express your true nature?

What about this curious complementary color? Is it your least favorite color?

Are these attributes that you wish people knew about or you would like to acquire?

Using this complementary color in your super costume isn't considered necessary. Find another way of demonstrating these hidden qualities. If they are not your qualities, they may be the annoying qualities of your arch nemesis.

Your color selections will give you more insight into possible supernames and powers.

colors

				yellow 28	gold 29	orange 30	orange red 31

peach 32	coral 33	scarlet 34	red 35	maroon 36	crimson 37
rose 38	magenta 39	pink 40	orchid 41	plum 42	purple 43
mauve 44	violet 45	indigo 46	ultramarine 47	blue 48	azure 49
cyan 50	sky 51	aquamarine 52	turquoise 53	teal 54	emerald 55
pine 56	forest 57	green 58	leaf 59	lime 60	olive 61
brown 62	beige 63	white 64	silver 65	gray 66	black 67

inspiring
expressive
cheerful
welcoming
bright
communicative
electrifying
empowering
just
evident

yellow

successful
enthusiastic
radiant
extravagant
lavish
solid
conspicuous
rich
substantial
valued

productive
amicable
abundant
contented
fertile
distinctive
happy
equable
participatory
prosperous

orange

dynamic
competent
enjoyable
impatient
lively
motivated
organized
tempting
vital
inclusive

orange red

accepting
approving
assured
altruistic
considerate
attentive
inviting
kind
social
cozy

peach

energetic
charitable
agile
appealing
confident
ecstatic
explosive
glorious
vehement
stimulating

coral

active
ambitious
assertive
challenging
courageous
exuberant
exciting
gregarious
initiating
fiery

scarlet

powerful
persuasive
positive
aggressive
alert
believable
dramatic
ardent
effective
obvious

red

affluent
candid
devoted
decorous
elaborate
mature
sensitive
sensual
obstinate
seasoned

maroon

resilient
protective
formidable
dashing
impulsive
forthright
vigorous
visceral
proud
stout

crimson

responsive
splendid
amorous
maneuvering
heartfelt
intricate
keen
copious
tenacious
insistent

rose

passionate
bold
dedicated
enchanting
optimistic
striking
arousing
unabashed
vivacious
vivid

magenta

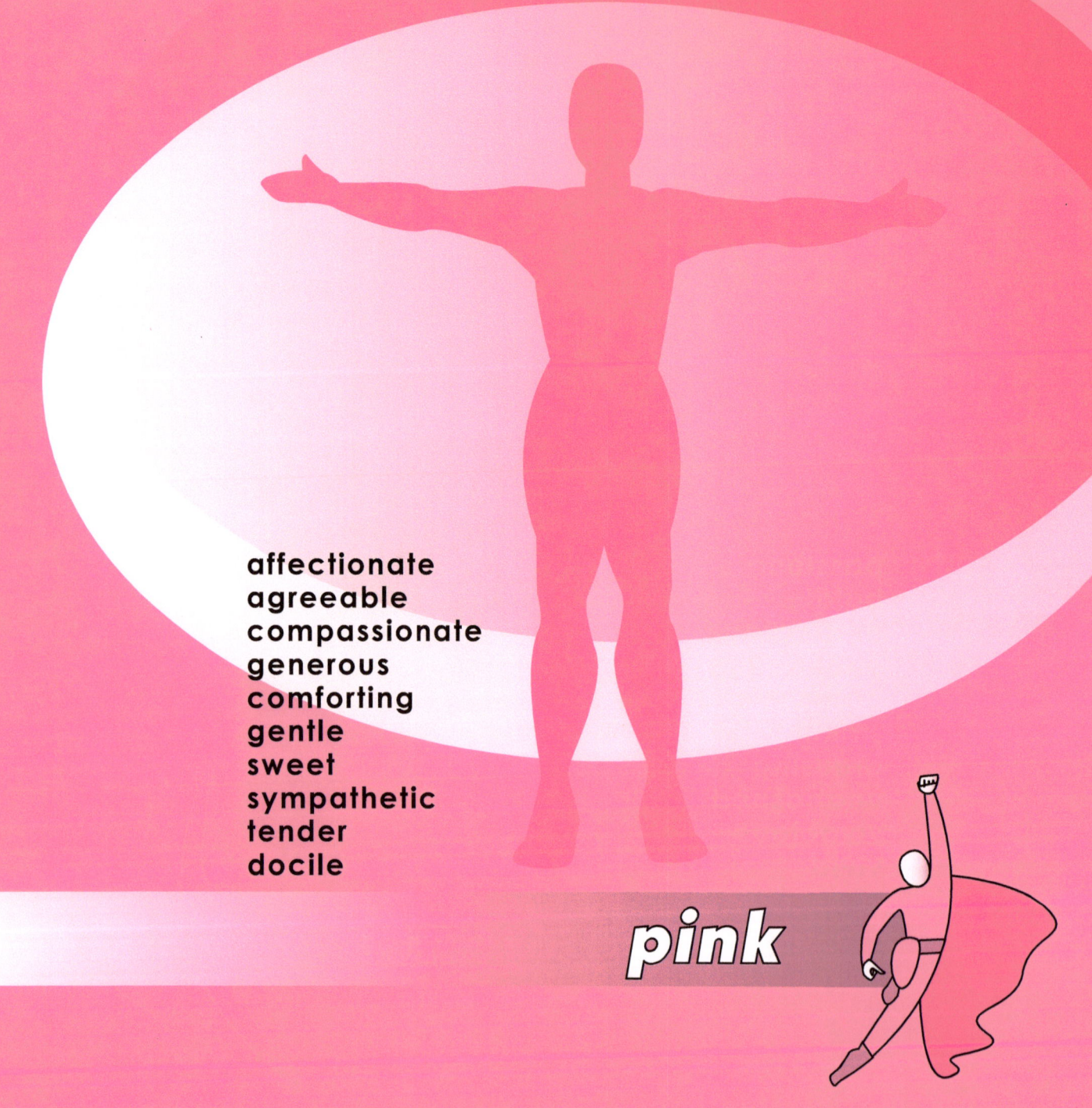

affectionate
agreeable
compassionate
generous
comforting
gentle
sweet
sympathetic
tender
docile

pink

conscious
mild
gracious
emotional
genteel
civilized
indulgent
sociable
useful
charming

orchid

noble
collected
luxurious
smooth
fascinating
experienced
tactile
certain
valuable
reactive

plum

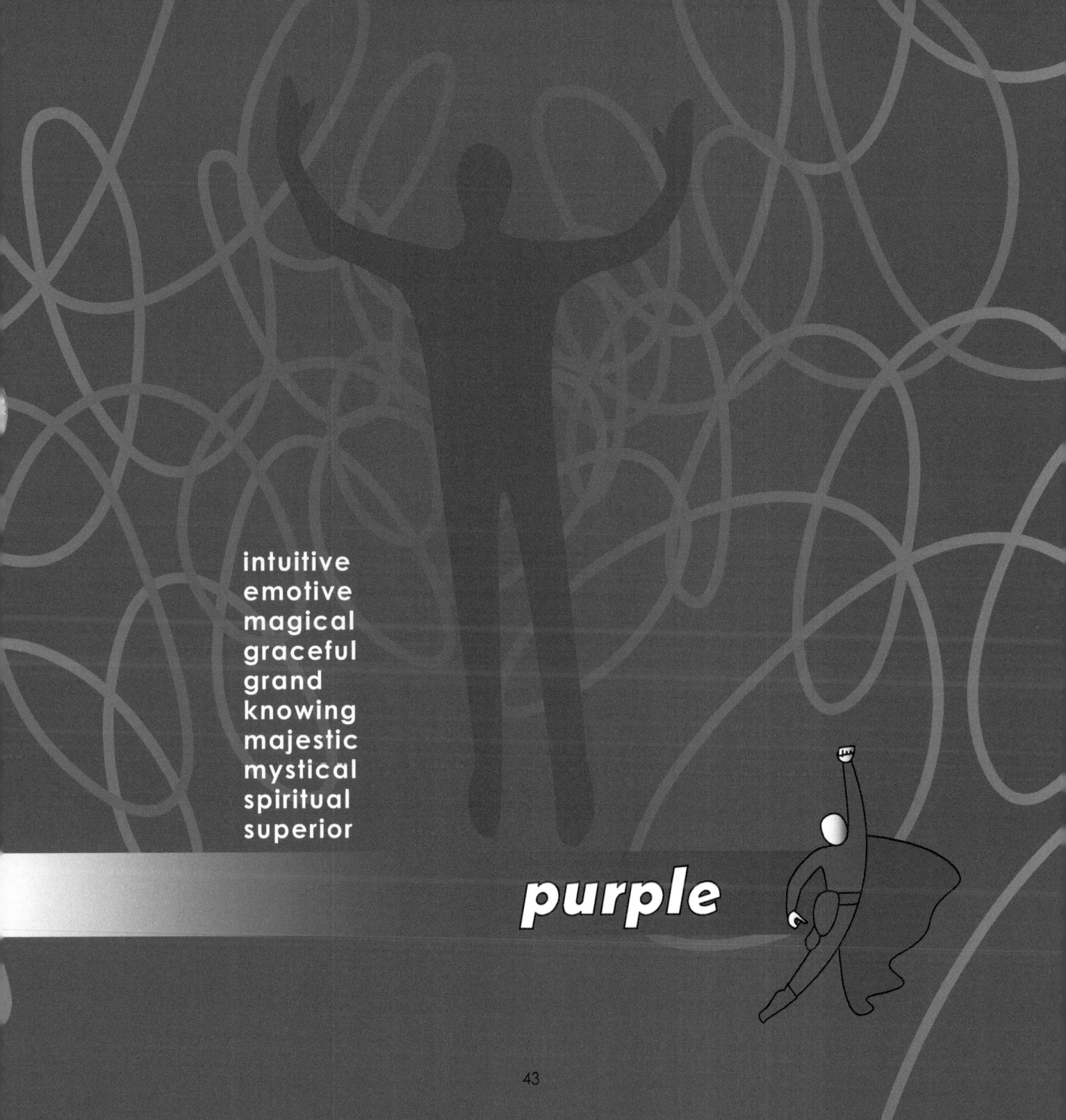

intuitive
emotive
magical
graceful
grand
knowing
majestic
mystical
spiritual
superior

purple

audacious
excessive
empathetic
exotic
flamboyant
impressive
royal
soulful
stylish
worldly

mauve

thoughtful
resolute
complex
aristocratic
elegant
mysterious
precious
sophisticated
still
appreciative

violet

purposeful
dependable
moving
accurate
qualified
discerning
serious
discrete
deep
balanced

indigo

authoritative
adept
settled
apt
respectable
arduous
absolute
extreme
static
conclusive

ultramarine

rational
earnest
responsible
commanding
sincere
intelligent
loyal
peaceful
professional
truthful

blue

faithful
cultured
upright
consistent
capable
engaged
resolute
realistic
contemplative
constant

azure

imaginative
patient
analytical
approachable
clean
creative
perceptive
sharp
ingenuous
true

cyan

elevating
cooperative
pleasant
virtuous
trusting
light
innocent
dreamy
contemplative
mutable

sky

serene
tranquil
amenable
communal
buoyant
effortless
alluring
modest
carefree
fluid

aquamarine

diplomatic
instinctive
profound
introspective
prolific
collaborative
persistent
harmonious
collected
effusive

turquoise

idealistic
insightful
inventive
beneficial
exacting
faithful
astute
refined
sensible
sentimental

teal

composed
eternal
exquisite
astute
involved
restless
strong
suave
wise
meticulous

emerald

stoic
sure
lofty
selective
solemn
untamed
remote
sound
diligent
observant

pine

humanistic
supportive
accessible
benevolent
healing
open
prudent
scientific
trustworthy
unselfish

green

progressive
fresh
novel
determined
fruitful
sporadic
wholesome
evolving
avid
fragile

leaf

**adventurous
changeable
eager
innovative
festive
healthy
naïve
refreshing
young
critical**

lime

calm
hospitable
lenient
neutral
placid
circumspect
safe
simple
subtle
reserved

acute
egocentric
ethereal
individualistic
neat
proper
pure
simplistic
untouched
bare

white

aware
dignified
flexible
luminous
reaching
reflective
starry-eyed
winning
spry
pensive

silver

careful
formal
humble
noncommittal
passive
quiet
reasonable
reputable
sedate
moderate

gray

dark
disciplined
forceful
independent
intense
opinionated
guarded
restrained
secretive
fastidious

black

Little things you can do as a Superhero to help humanity

★ Keep up on current affairs locally and globally.

★ Pursue your passions.

★ If you can, donate blood.

★ Support the arts, sciences, and education.

★ Keep an eye out for pedestrians.

★ Renew resources.

★ Laugh more.

★ Vote.

★ Fill your ice cube trays.

★ Give, ask for, and reward excellence.

Superpowers

Superpowers are strengths and forms of expression. You express yourself through your talents, skills, projects, and accomplishments. Expression generates action, effects, and response.

Superheroes have the courage to encourage the use of superpowers in others and themselves. It is vital to foster those positive results that ensue when people have the opportunity to shine using their unique superpowers.

To identify your superpowers, first think about your personality type.

What makes you one of a kind? Who are you? What do you do? Are you strongly one personality type or a mixture several?

expressive & enthusiastic

emotional & practical

intellectual & spiritual

Superpowers, Strengths, Challenges, Limitations, and Learning

Your personality traits lead to how you participate in the world through your superpowers. You contribute to society, experience your best self, and feel empowered by actively connecting and expressing your feelings, thoughts, endeavors, and dreams with the world.

What kind of superpowers do you have? What are you really good at?

Go on and brainstorm your unique abilities! Remember, like the colors choices, your superpowers change and transform.

As you brainstorm, make a list with two columns: one for your superpowers and the other for your challenges. One superhero's challenge may be another's superpower. Strange, but true.

Challenges can be difficulties, limitations, weaknesses, or something you want to overcome or improve on. Defining your challenges sometimes isn't that straightforward and it isn't negative. Through careful consideration, it enhances what you are awesome at doing and encourages collaboration with superheroes with complementary superpowers that achieve excellent team building.

The quest for high proficiency in your superpowers encourages lifelong learning, research, and practice. Identifying and revealing superpowers and challenges provides opportunities to pursue your passion. Destiny is calling to give you the chance to take the path that best suits your abilities and interest. You get to save the day by just being the best you!

Review these superpower possibilities and examples to consider your own weaknesses and strengths. You will discover many more on your own.

Case Study: Bow Girl

Subject: Superpowers and Challenges

Bow Girl's superpowers of consideration, action, and self-motivaed achievement are balanced by her challenges of frustration with other's intentional or oblivious discourtesy, ambiguity, and the parlizing inactivity caused by opinons. She is empowered with bold activation, problem-solving perseverance, and creating acceptance through art. Bow Girl is often described as "too bright." She is comfortable stepping forward and up while standing out, but it makes her a very obvious and easy target as well.

Bow Girl's

Superpowers	Challenges
Instruction ↔	Educates incessantly
Initiation ↔	Trouble finishing
Creative distinction ↔	Fear of obscurity
Patience ↔	Stubborn
Leadership ↔	Difficulty following
Humor ↔	Desire to be taken seriously
Remarkable color use ↔	Persnickety palette
Enthusiastic ↔	Melancholy upon success
Transparent ↔	Never invisible
Encouraging to others ↔	Perplexed by discouragement
Precise and elaborate ↔	Idealist, not a perfectionist
Takes on bullies ↔	Thin-skinned

Capability and Control

- Assertiveness · Constructive Rage
- Coyness · Disruption
- Exaggeration · Focus
- Healing · Magnetism
- Manipulation · Cooperation

Intellect Enhancement

- Articulation · Clairvoyance
- Daydreaming · Empathy
- Invention · Multitasking
- Sympathy · Telepathy
- Jedi Mind Trick · Trivia

Perceptive Powers

- Bargain Identification
- BS Detection · Big-Picture Vision
- Competence Detection
- Environmental Attentiveness
- Movie Reviewing · Sensitivity
- Stereotype Smashing

Physical Amplification and Alteration

- Flexibility · Imitation
- Invisibility · Lactose Intolerance
- Maturation · Nudity
- Transparency · Rhythm

Protective Powers

- Body Shielding with Objects
- Connections · Force Field
- Just Walk Away Armor
- Good Reputation · Reflection
- Resistance · Humor

Material Transformation and Fabrication

- Acts of Creation and Creativity
- Event Planning and Execution
- Production or Improvement of Objects or Machines
- Fondue Craft · Looks good in a hat

Supername

Your supername is a representation of your motivations, abilities, and/or attributes. Many names include exciting adjectives that relate to your superpower or that summarize your personal mission.

Your supername might be a title (Your Honor) or a single, powerful descriptor (Cadence). There are no rules, but think about what you want people yelling at you.

Remember, you can always change it.

If you get a chance, you might include a list of words that rhyme with your supername for later use in your theme song.

BOW GIRL
aka Your Brightness
Action-Packed Superhero

Benefits of Name Tags

1. Makes introductions a breeze.
2. Eliminates forgotten-name embarrassment.
3. Develops public responsibility.
4. Misspelling of name revealed gently.
5. Everyone is just so friendly then.

Case Study: Bow Girl
Subject: Supername

bow – (v.) to bend with respect and courtesy;
(n.) knot or loop

girl – (n.) small female.

An Impediment is an Opportunity

When your survival is at risk, superheroes react in these ways:

fight flight fix freeze facilitate forfeit fain fire forgive fondue

Because melted cheese and chocolate solve everything!

Improvement and Acceptance

Action-Packed Superheroes devote themselves to setting an example of what they truly desire. Evolution advances them into a creature merged of thought and conduct.

Many superheroes adopt a secret identity in fictional accounts to protect those close to them from evil villains. But in real life, superheroes shouldn't have to conceal themselves.

Action-Packed Superheroes are most feared for their honest perception and articulation of what they perceive. They strive for excellence that is strangely discouraged. The pursuit of education and expression is the way to become free of tyranny. The commitment to be yourself casts aside doubt and autonomy emerges.

Superheroes are not infallible; they are just like anyone else. Mistakes, misunderstanding, and missteps will happen. Superheroes accept what makes them different, driven, daring, and dynamically opposed to unproductive and petty behavior.

Understanding the efficiency of deliberate behavior may come as a subtle reflection or a boisterous declaration. This revelation launches you into the next ecstatic step of evolution. Now it's time to shed your mild mannered identity and be a hero visible all the time.

Case Studies

These are case studies of real people's actual Action-Packed Superhero personas. They are hopeful you will be inspired to create your own superhero. All of them wanted to assure you that they didn't figure out all of their attributes over night. Some took several months just on their name alone. Enjoy!

Utility accessory ideas

· clever thoughts notebook · pen · lip balm
· your hair stylist contact card · painkillers
· reality grappling hook · tissue

· change for a dollar · two for one dining coupons
· swiss army knife or leatherman · morph mints
· truth serum · a note from your mother

Cadence

Mission: He uses his sensitivity of waves to reflect the ideas and feelings he is exposed to. Colors: black - intense, gray - careful, purple - emotive

Superpowers	Challenges
Organization ↔	Ambiguity
Instinct ↔	Distraction
Detail ↔	Narrow focus
Boundaries ↔	Passive
Tone ↔	Temper
Rhythm ↔	Numerology
Communication ↔	Isolation
Inspiration ↔	Frustration
Regeneration ↔	Pain
Forecast ↔	Hindsight

Your Honor

Mission: She fights injustice, passionate for equality, dedication to free thinkers, and has propensity for judging others. Colors: purple - spiritual, olive - reliable, gray - modest

Superpowers	Challenges
Justice ↔	Intolerance of ignorance
Integrity ↔	Complacency
Dependability ↔	Laziness
Smartass ↔	Weak sense of entitlement
Puns ↔	Too-soft self esteem
Honesty ↔	Gossip
Charitable ↔	Fear of Failure
Sensible ↔	House-keeping
Literate ↔	Run-on sentences
Always returns cart to cart corral, no matter how hard it's raining ↔	Dining Out

Shield

Mission: She protects and nurtures others after being placed in positions of responsibility and independence early in life. Colors: violet - thoughtful, purple - intuitive, blue - responsible

Superpowers	Challenges
Inner strength ↔	Sense of responsibility
Empathy ↔	Mediating others' problems
Speaking with children ↔	Indecisiveness
Seeing beauty ↔	Lack of attention to detail
Encouraging others ↔	Burning bridges
Listening ↔	Involuntary invisibility
Intelligence ↔	Jumpiness/Worry
Storytelling ↔	Returning phone calls
Green thumb ↔	Sense of direction
Speed reading ↔	Paperwork

Synergy

Mission: He develops connections between unlikely and unusual resources to tap into the creativity of the universe. Colors: blue - intelligent, green - supportive, brown - honest

Superpowers	Challenges
Creative thinking ↔	Organization
Leadership ↔	Pulling Slack
Kindness to others ↔	Expressing anger
Putting people at ease ↔	Schmoozing
Learning languages ↔	Fashion sense
Loyalty ↔	Perfectionism
Open mindedness ↔	Focusing
Inspiring people ↔	Idleness
Animal telepathy ↔	Finishing
Able to navigate ↔	Crowded places

Sphere of Influence

Evolutionary journey from mere human, to superhuman, and finally to Action-Packed Superhero is as long as it is significant. Superheroes must go through all these stages of growth to germinate and continue an accumulation of observation and interpretation.

In early stages, superheroes may be discouraged by their perception that their heroic actions are not making the world a better place. They question if just one person can produce positive results.

Their investigation provides the not so obvious answer that superheroes are involved with several actions that influence change. Yes, one person can enhance our existence.

How?

Superheroes embrace the notion of the Sphere of Influence because their actions, ideas, or conduct can have a ripple effect on several others with whom they will never have direct contact.

Have you felt it?

Because the Sphere of Influence seems invisible, superheroes must believe that utilizing their superpowers has a wonderful effect on the world around them. Action-Packed Superheroes should always be on their best behavior and inspire the greatness of human potential.

How do you emanate a positive Sphere of Influence?

Ready for Action

Are you an example of intent, character, and integrity in action?

A stunning costume and catchy theme song help, but the core of an Action-Packed Superhero is being yourself and representing your passions in acts of positive influence.

Your intent and your action is how people appreciate you. With this perseverance, you have unique identity assets. Reflect on your Authentic Superhero Identity Assets of Integrity, Intensity, Fidelity, and Ability.

What do you see in yourself?

Integrity - Consistency of Character

Integrity is persistence in values, conduct, actions, methodology, observations, expectations, and reactions.

	Reliable	Apathetic	Unconventional	
Respectful	Lawful Good	Neutral Good	Chaotic Good	Altruistic
Complacent	Lawful Neutral	Neutral Neutral	Chaotic Neutral	Objective
Inconsiderate	Lawful Evil	Neutral Evil	Chaotic Evil	Selfish
	Steadfast	Inactive	Adaptable	

In Advanced Dungeons and Dragons by Gary Gygax and David C. Sutherland III, characters have alignment which is a classification of people's ethical and moral perspective. Adding integrity aspects to these role alignments are a way to understand your own and others behavior, outlook, and intention. Acknowledgment of juxtapose stances reveals a superhero's appreciation of different approches. Chaotic isn't actually bad, but evil is still evil. Situations change, but often your alignment doesn't which is fundamental for your relationships in the world.

Intensity - Focus on Your Passion

Intensity is significant, concentrated attention, inspiration, determination, and enthusiasm.

Search for your own lasting pursuit and connection. Narrowing your depth of field increases and sharpens focus, convergance, and clarity.

Fidelity - Be a Star

Fidelity is faithful output with high quality accuracy, effective amplification, influential proliferation, and relentless radiance.

It is an expanding universe, so there is enough room for us all to be stars.

Ability - Recognize and Reward Excellence

Ability is active, achievable aptitude in development, application, and delivery of beneficial skills, intellect, wisdom, and the acknowledgment of potential in yourself and others.

Your personality traits lead to how you participate in the world through your abilities or superpowers. You contribute to society, experience your best self, and feel empowered by actively connecting and expressing your feelings, thoughts, endeavors, and dreams with the world.

Etiquette

A simple way a superhero can affect the world around them is through etiquette. Here's Bow Girl's top picks for everyday polite and ethical behavior:

· Say please and thank you.

· Keep eye contact when speaking or listening to another.

· Open doors for others and thank those who open or hold doors for you.

· Give credit where credit is due.

· Wait and take your turn.

· Tip generously.

· Don't impose.

· Log complaints with someone who can do something about it.

· Give solutions, not excuses.

· Try not to waste life on negative things, over analysis, or indecision.

· Excuse yourself if you interrupt a conversation or person's line of sight.

· Make introductions.

· Shake hands that are extended or extend yours.

· Don't turn your back to people.

· When listening, try not to interrupt.

· Include people in conversation.

· Meet people at their level.

· Be happy for others.

· Signal your intent.

· Show respect.

· Smile.

Reputation and Responsibility

Be consistent and only use your powers for good!

Lead by example!

Now! Go! Get out there and be super!

Your Action-Packed Superhero Profile Pages - Superhero Origin Story

Your Action-Packed Superhero Profile Pages - Transformation Into a Superhero

Your Action-Packed Superhero Profile Pages - Catalyst

Your Action-Packed Superhero Profile Pages - Super Colors and Branding

Your Action-Packed Superhero Profile Pages - Super Expression and Costume

Your Action-Packed Superhero Profile Pages - Superpowers

Your Action-Packed Superhero Profile Pages - Super Name

Your Action-Packed Superhero Profile Pages - Identity Assets

be super!

Thank you very much!